T0160400

RED

Other Books in the Series:

Colors by Giovanna Ranaldi

Blue by Valentina Zucchi and Viola Niccolai

White by Valentina Zucchi and Francesca Zoboli

Black by Valentina Zucchi and Francesca Zoboli

Yellow by Valentina Zucchi and Sylvie Bello

Green by Valentina Zucchi and Angela Leon

RED

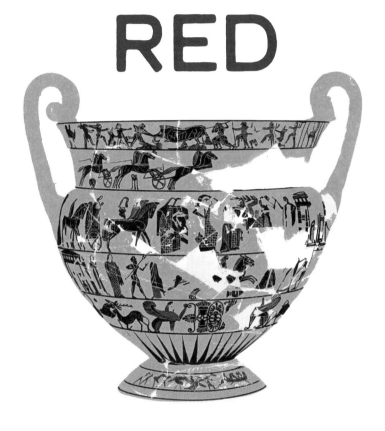

BY VALENTINA ZUCCHI
AND PAOLO D'ALTAN

Translated from the Italian
by Katherine Gregor

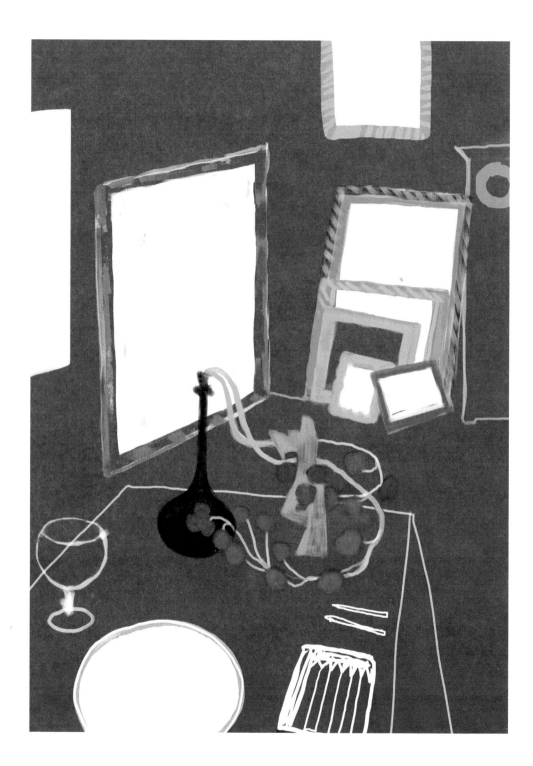

CONTENTS

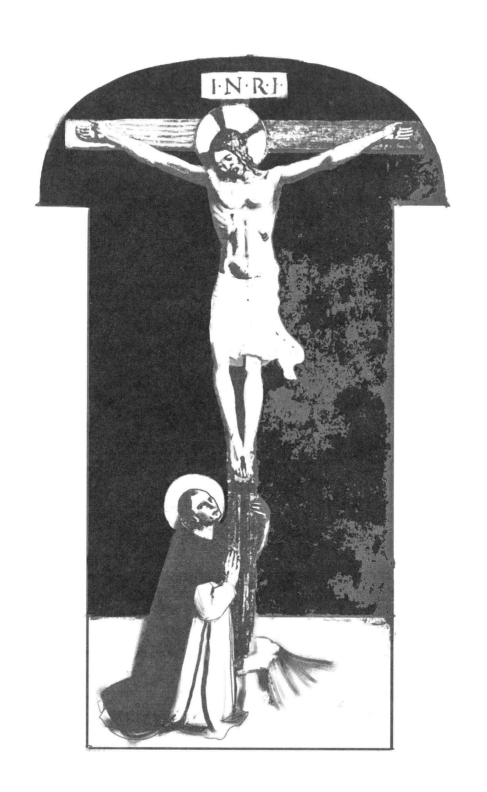

EXPLORING RED

Let me introduce you to red, the prince of colors. Red is proud, lively, and powerful. It conjures up fire, blood, and passion.

Perhaps it would be better, though, to use the plural because there are many different reds: we have Tyrian purple, crimson red, minium red, cinnabar red, scarlet red, vermilion red, cadmium red, carmine red, ochre red, brick red, alizarin red, amaranth red, Burgundy red, coral red, pomegranate red, Persian red, Pompeian red, Valentino red, Venetian red, rust red, cardinal red, cherry red, strawberry red, Mars red, and Pozzuoli red. In other words, reds make up a very large family.

Let's try to get to know at least a few of them, and the ones we choose first are the ones artists have loved the most. So let's investigate and see which ones express our creative passion.

Throughout the book, you will find spaces to extend drawings, try out suggested exercises, make your own sketches or notes and write your impressions about what you see, notice and think. Make sure you always have a notebook with you so you never lose a creative idea or impression.

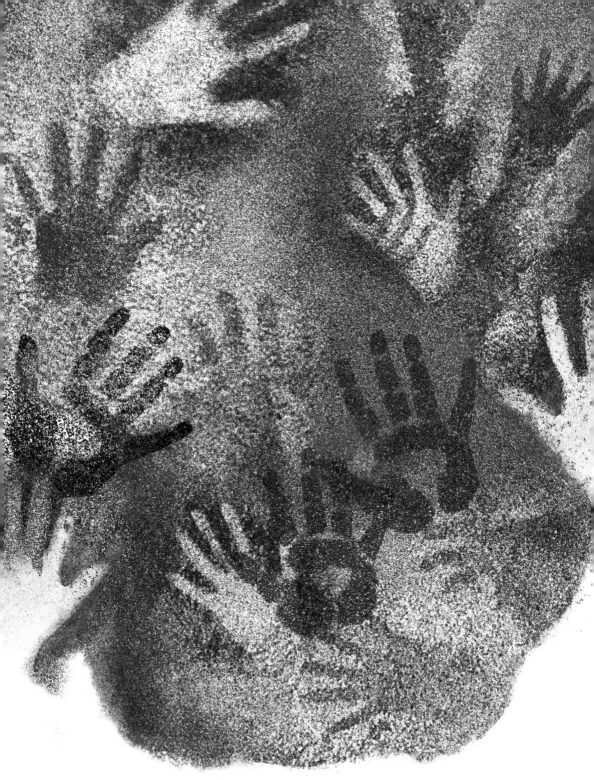

PREHISTORIC PAINTINGS

The first drawings made by humans were red. To produce them, thousands and thousands of years ago, prehistoric people ground hematite, a ferrous stone, to dust and used it to paint their images. In the caves they inhabited, they would depict animals such as bison, deer, horses, and mammoths; but they would also leave impressions of their hands. These impressions were created in various ways: by plunging their hands into the paint then pressing them on the rock, or by following their outline with a finger, or else by pressing their hand on the rock and spraying paint around them with rudimentary straws. That was the first red used by humans.

Making Your Mark

Leaving an impression of your hand means leaving your mark. You can do it on the sand or on a steamed-up window but also on paper.

You can try any of the methods used by the prehistoric painters so first take a red watercolor, spread it on the palm of your hand using a brush and quickly press the red hand on the paper. Then try using negative spaces. Press your hand on the paper and draw the outline, or spray round it. As the color builds up, you can create some subtle and beautiful patterns using only the one color.

DRAWING IN SANGUINE

The favorite pencil of artists is red and called sanguine. The word conjures up blood but it only has this name because of its color. Sanguine is also obtained from hematite, worked and formed into sticks. During the Renaissance, all artists used it to practice their drawing or to sketch their work in sanguine before painting it. Leonardo da Vinci used sanguine for many of his drawings, including a self-portrait.

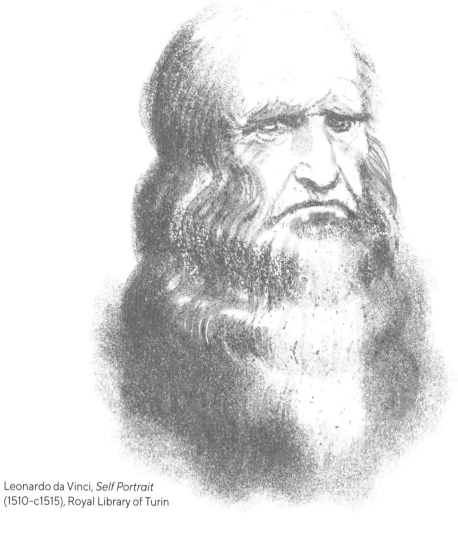

Leonardo da Vinci, *Self Portrait*
(1510-c1515), Royal Library of Turin

Drawing a Leonardo Portrait

Sticks of sanguine are readily available in art stores or online but if you can't wait to start drawing, you can use an ordinary red pencil instead. Drawing a portrait demands a lot of work because you want to capture not just what the person looks like but the essence of their personality. While you are copying the Leonardo portrait, think about ithe qualities of sanguine and how easy or difficult it was to use.

Self-Portraits

Now you have tried drawing a face, you can experiment with more, as you will need considerable practice to hone your skills. Use the sanguine again to do a self-portrait. It's not easy: you must look at yourself in the mirror and draw what you see. If you find it too complicated, you can do the portrait of a friend instead.

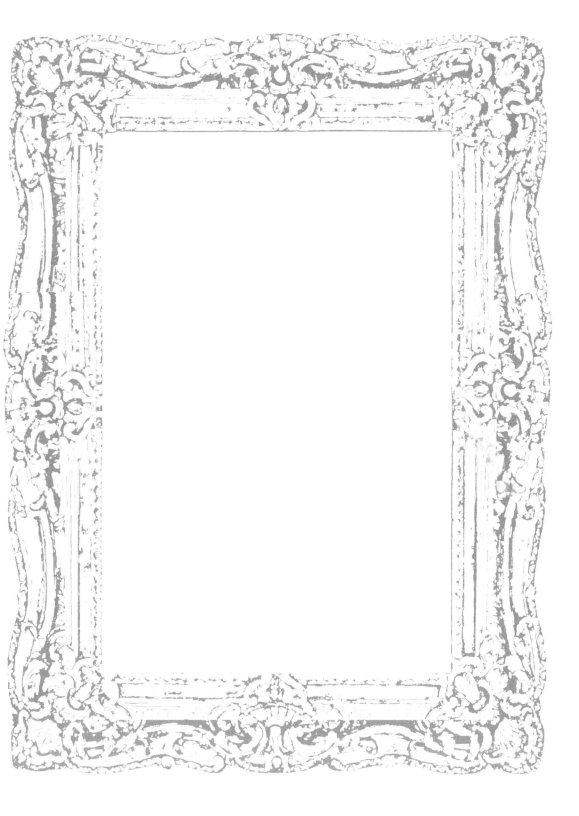

RED FROM THE EARTH

The first red came from stones and the soil. As a matter of fact, many vases, amphorae, and cups modeled by the ancient Greeks were made from terracotta and are now in museums all over the world. These are decorated vases on which events were painted in black on a red background. Then there came a point when people began to do the opposite: after sketching the drawing, the craftsman would paint the background black and leave the terracotta red for the patterns. This made it easier to show details, such as the features of the faces and garments.

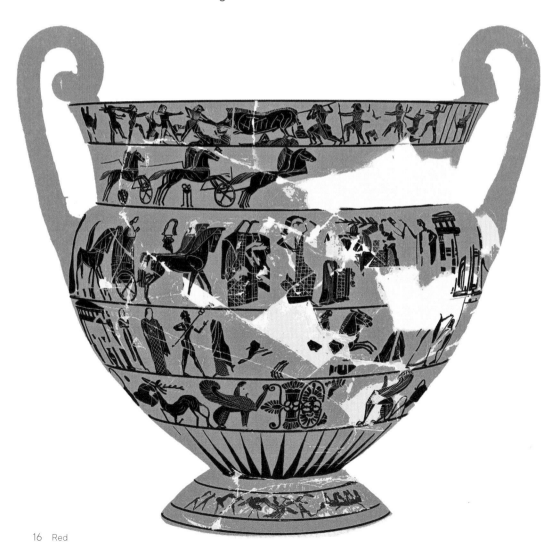

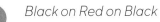

Black on Red on Black

Select an individual from the vase and draw them in black on a red background, then draw the same person in red on a black background.

In the Greek style, create one or two of your own figures and see the difference when you draw them in red on a black background, then in black on a red background.

Ergotimos and Kleitias, *The François Vase* (570 BCE),
National Archaeological Museum, Florence

Create Your own Greek Frieze

This illustration shows a large vase known as a crater, just like the crater of a volcano, in which wine was mixed at banquets. Look at the frieze around the bottom and how we have shown the figures in red on black and black on red. Practice drawing a story below, then draw it on the vase using these techniques.

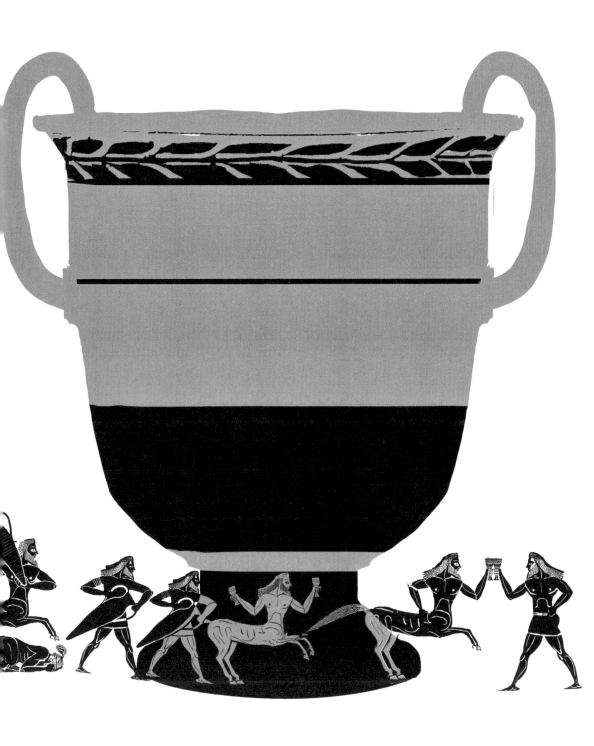

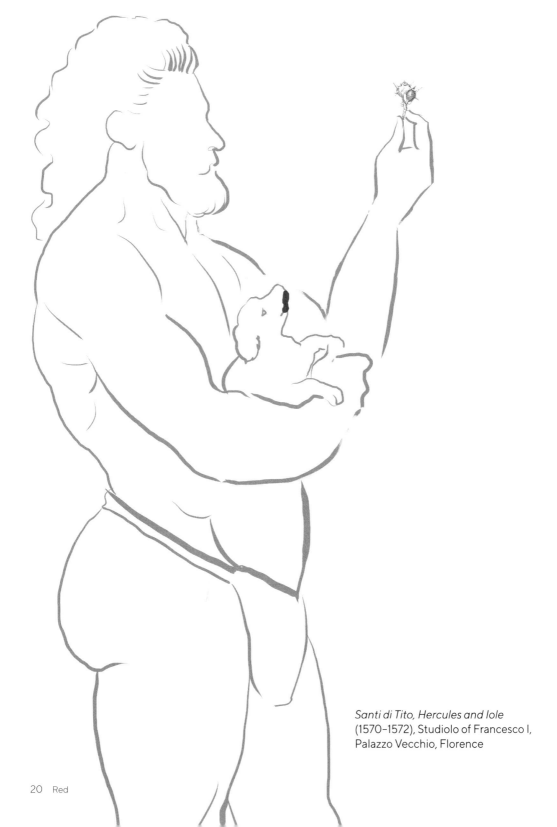

Santi di Tito, Hercules and Iole
(1570–1572), Studiolo of Francesco I,
Palazzo Vecchio, Florence

TYRIAN PURPLE

The most famous of all reds is Tyrian purple, the most valuable in antiquity: it cost as much as gold and only kings, princes, and emperors could afford it. Because it was extremely expensive, it became the symbol of wealth and power.

It was obtained from a small mollusc; you could only get a drop from each one so millions had to be ground in order to dye one piece of fabric! Legend has it that it was discovered by the ancient Greek hero Hercules. One day, his little dog went close to a shell on the beach and when he returned, his mouth was stained with red.

Drawing Hercules' Dog
Draw your version of Hercules dog, with his red mouth, in the space below.

Regal Garments

Emperor Justinian and the Empress Theodora – illustrated here – are wealthy and powerful, so they are wearing Tyrian purple garments. Add the appropriate colors to their ceremonial garments to ensure that they predominate in the picture. Choose the colors you like for the clothes of the other characters.

Justinian and Theodora Panels (6th century AD), Basilica of San Vitale, Ravenna

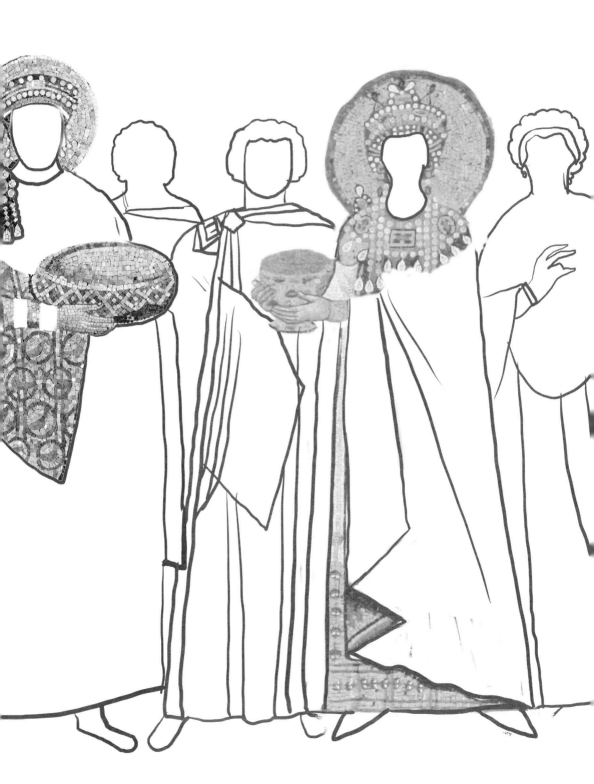

DRAWING FABRIC

In the old days only rich people could wear red clothes. As a matter of fact, even after they discovered that a new red could be obtained from a tiny insect – Kermes, or crimson – red remained an expensive color. That is why on important occasions, the Pope and the cardinals would all wear red – and still do.

Two great artists, Raphael and Titian, managed to convey the red of their clothes very skillfully.

Drawing Skills
Practice your painting skills by filling in the outlines of the grandson standing behind the Pope, making sure the Pope remains the most prominent figure.

Titian, *Pope Paul III and His Grandsons*
(1546), Museo di Capodimonte, Naples

Creating Textures

Even if it's not easy, practice coloring clothes red, trying to imitate the type of fabric you can imagine in the pictures: soft velvet, shiny silk, plain cotton, and coarse canvas.

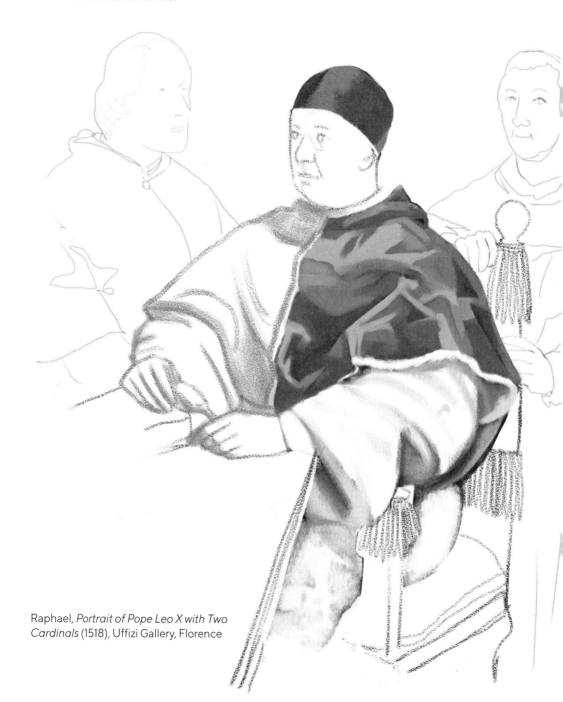

Raphael, *Portrait of Pope Leo X with Two Cardinals* (1518), Uffizi Gallery, Florence

RED AND POWER

Many famous men and women chose red when it came to being immortalized by painters. Piero della Francesca clothes the Duke of Urbino, Federico da Montefeltro, in red, in a formal pose. If you try looking around, you will find many other powerful people in red, like the pensive Cosimo de' Medici the Elder in the portrait by Pontormo.

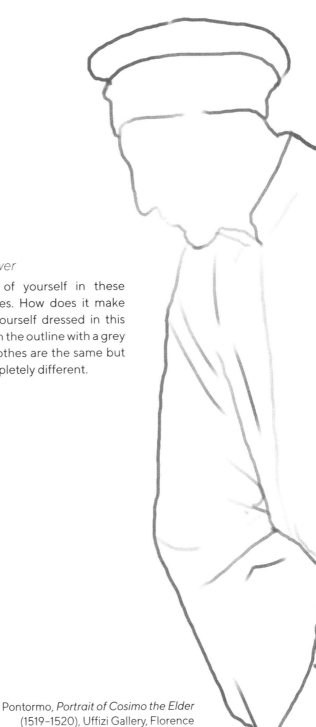

In a Place of Power

Draw a portrait of yourself in these powerful red robes. How does it make you feel to see yourself dressed in this color. Then color in the outline with a grey or brown – the clothes are the same but the impact is completely different.

Piero della Francesca, *Federico da Montefeltro*, (1465-1472), Uffizi Gallery, Florence

Pontormo, *Portrait of Cosimo the Elder* (1519–1520), Uffizi Gallery, Florence

The Richest Color

Imagine you're a king or a queen; choose what you think are an appropriate pose and clothes. You can draw yourself in profile, standing or sitting; while writing or playing; wearing a rich sumptuous cloak or your favorite pants. Only make sure you color them red.

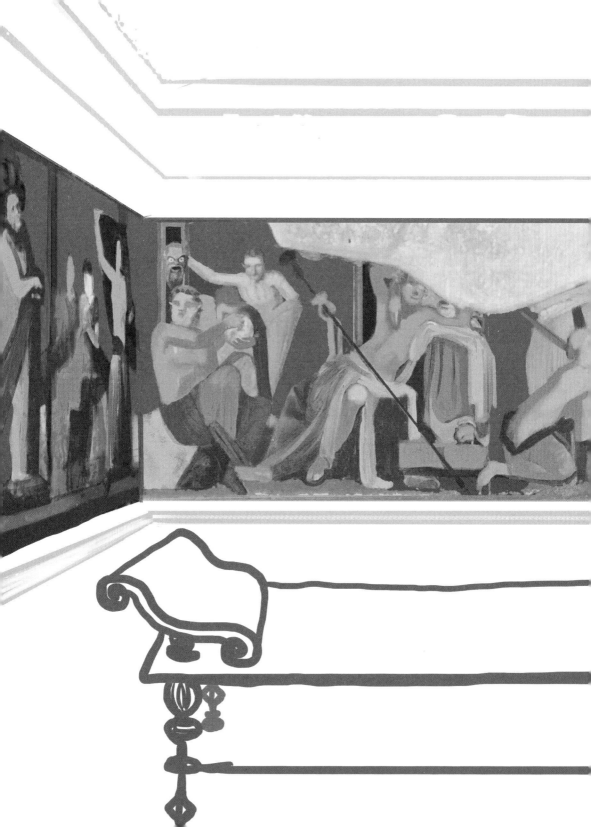

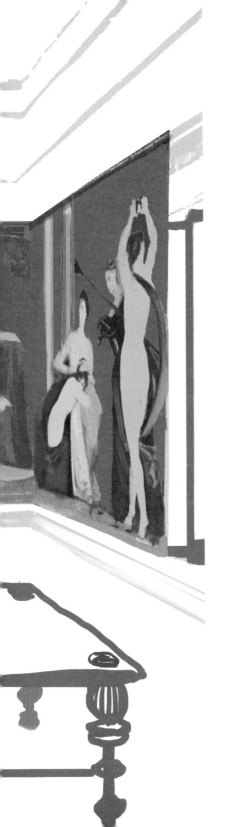

POMPEII

Another famous red is Pompeian red. The name comes from Pompeii, an ancient Roman city overwhelmed by the eruption of Mount Vesuvius one morning in 79 AD. The city has now been excavated and tourists from all over the world can see the temples, theaters, and luxurious houses that were preserved under the ashes. Wonderful frescoes exist in some of the houses, with walls often characterized by a fiery red. Walls are painted with landscapes, buildings, and gardens, like in the puzzling Villa of the Mysteries, where life-size figures stand out against a bright red background.

Triclinium, Villa of the Mysteries (1st century BCE)

A Classical Fresco in Your Room

How often have you wondered about drawing on or painting your bedroom walls (or perhaps you've even done it)? Imagine what you would like to see in front of you when you first wake up in the morning, and feel free to decide which colors to use.

Furniture in the Red Space

Now you have depicted the scene you would like on your bedroom walls, try creating different pieces of furniture that might go in your space. How do modern and ancient furniture compare?

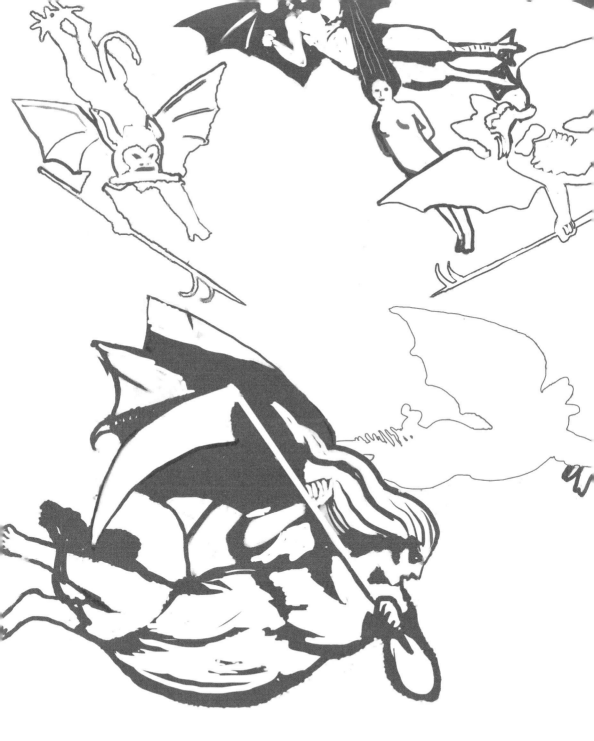

Buffalmacco, *The Triumph of Death*
(1336–1341), Sinopie Museum, Pisa

THE INVISIBLE RED

A favorite red among artists is sinopia, obtained from a dark red earth in Sinop, a city in Turkey. They used it to sketch drawings directly onto the vaults or walls with a brush, before painting frescoes. That is why sinopia is almost always invisible, covered with a thin layer of plaster on which artists then created the actual painting. We can only see it reappear in spots where this layer has chipped off. When you are painting, it's always good to have a clear plan in mind before you pick up your brushes.

The Triumph of Death
Think about what you would like to draw to complete the painting. With a soft red pencil, sketch in the basics of what you want to include before defining the lines with a nice red felt-tip pen.

The Fight Between Good and Evil

Look at the original painting if you can so you can understand the power of the images. Choose one element of the picture and draw it in more detail, using a red pen or pencil, or you could even paint it in acrylics or watercolor.

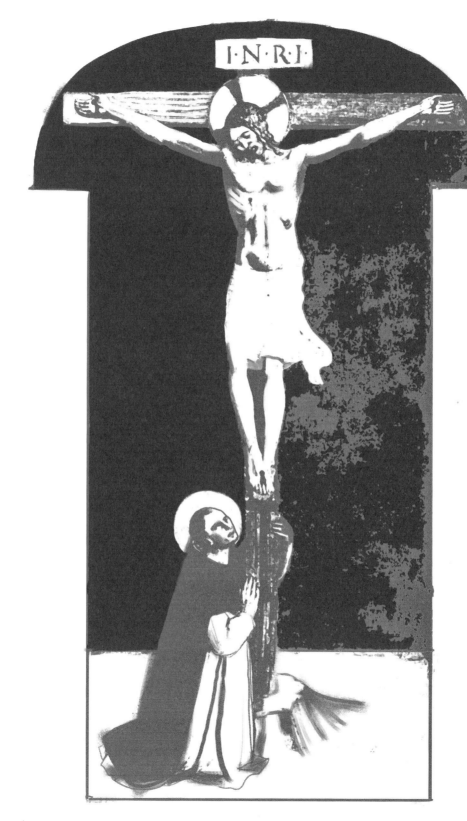

Fra Angelico, *Crucifixion* (1441–1442), Museo di San Marco, Florence

THE BASE RED

Morello red is also almost always concealed: it was used as a base for azurite, a beautiful blue that had the advantage of being cheaper that lapis lazuli but the drawback of turning into dust with time. Like all colors obtained from stones, morello red was also ground very finely. In his *Craftsman's Handbook*, which divulges all the secrets of 15th-century painting, Cennino Cennini suggests first using a bronze pestle and mortar, then a stone – ideally porphyry, because it's hard and sturdy – for grinding colors.

Drawing on a Colored Base
Practice copying this image, remembering that the red is the base color.

Omnes

meum Domine

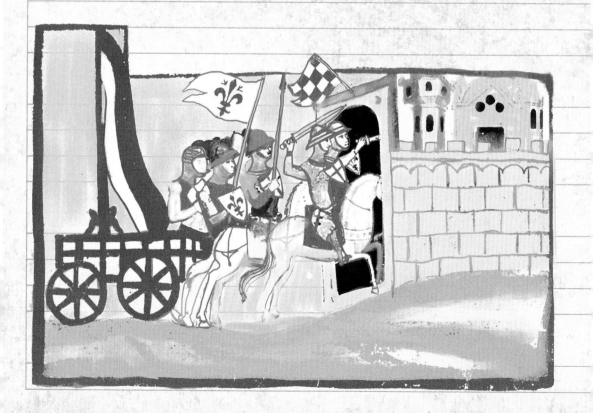

MINIATURES

Among the reds described by Cennini, there were two other important ones: the first is minium red, which back then corresponded to cinnabar. It's the color that gave its name to an entire style of picture: miniatures, in other words the patterns that adorned illuminated initials, title pages, friezes or entire pages of old manuscripts. This is because, once upon a time, books were not printed but written and decorated by hand one by one and were therefore very valuable.

Giovanni Villani, *New Chronicles, Chigi Manuscript L VIII 296* (14th century), Vatican Apostolic Library, Rome

Penmanship

Try writing your name in beautiful handwriting – use a brush if you prefer – using the lines to guide you. Remember that there were no excuses for a mistake!

Illumination

Choose your name or another word if you wish, and create an illuminated first initial using red as a main color. You might choose it for the background or the foreground but try to make it predominant.

ABCDEFG

abcdefgh

Marco Marchetti, *Hercules and the Apples of the Hesperides* (1556–1557), Palazzo Vecchio, Florence

DRAGON'S BLOOD

One of Cennini's reds you might prefer is dragon's blood: who knows how many knights must have cheated death to bring painters this color! In actual fact, this red was obtained from the resin of a tree which, legend has it, had sprung from the blood of Ladon, the monster that guarded the golden apple tree in the Garden of the Hesperides. Hercules killed it in one of his famous twelve labors. This red is still used, especially to treat furniture and the most famous violins in the world, the Stradivari.

Hercules Brought to Life
Draw the rest of the image.

FLORENTINE RED

Rosso Fiorentino (Florentine red) is, in fact, not a color but a painter. His real name was Giovan Battista, but he was called Rosso because he was a redhead. An eccentric, imaginative artist, he became successful at the court of the French King Francis I. Rosso Fiorentino and the artists in his circle used a totally different palette for their paintings than had been favored up to that point; it was flamboyant, luminous, and explosive. It's not easy to choose the colors for a painting or a drawing. Every color has a thousand different shades that are forever changing depending on the light and whoever is looking at them.

Rosso Fiorentino, *Descent from the Cross* (detail) (1521), Pinacoteca, Volterra

TITIAN

From Florence to Venice, red becomes Titian. Venetian artists have always been the most talented with colors: they would spread them layer after layer, glaze after glaze, to obtain a soft and very realistic effect. Titian's *Assumption of the Virgin* is a perfect example: accompanied by the awe-struck apostles, surrounded by angels and blinded by Divine light, she looks genuinely alive in her red dress and blue cloak.

Titian, *Assumption of the Virgin* (1518), Santa Maria Gloriosa dei Frari, Venice

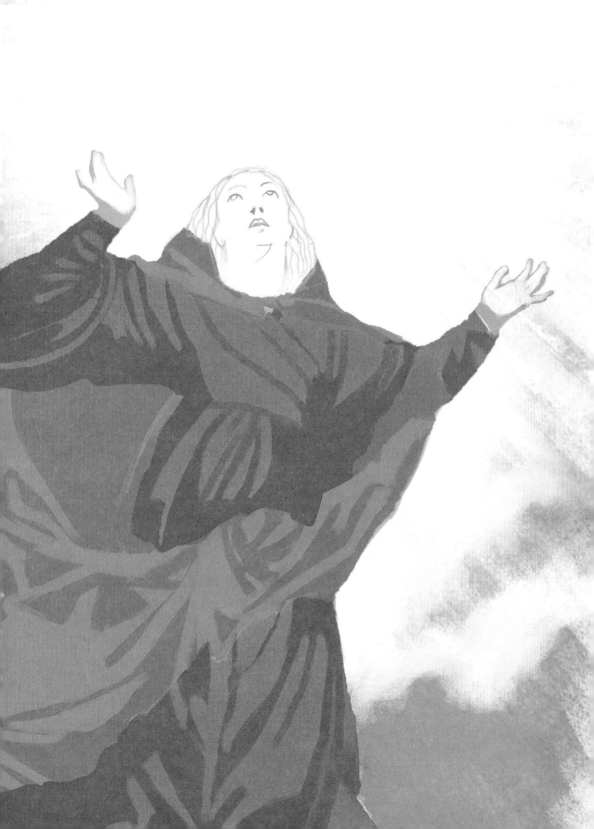

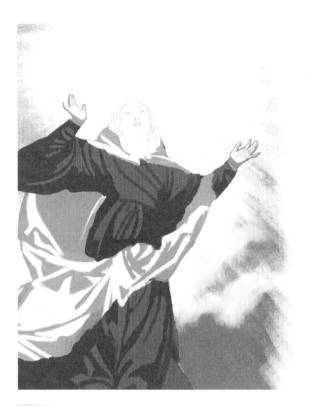

Mary in Color

Artists have often painted the Virgin Mary in these colors. The red means that, like us, she is human, while the blue reminds us that she is also a heavenly creature, close to God. You can look through an art book or search on the internet to find more examples.

Then think about the color of your ideal outfit. Which of these three color combinations says the most about you? Or none of them? Paint the colors that suit you best.

MIRACULOUS PICTURES

Rothko, an important 20th-century painter, also liked red very much. Actually, he liked all colors, so much so that he painted nothing else. He would prepare large canvasses on which he would spread thin layers of color, luminous, and transparent, one on top of the other: true expanses of color capable of bewitching the viewer and triggering a powerful emotion in them because, as Rothko wrote, "Pictures must be miraculous".

Your Color Field

If you had to choose a "color field" into which you could dive and disappear, which among these would you pick? Do you want to color your own color field?

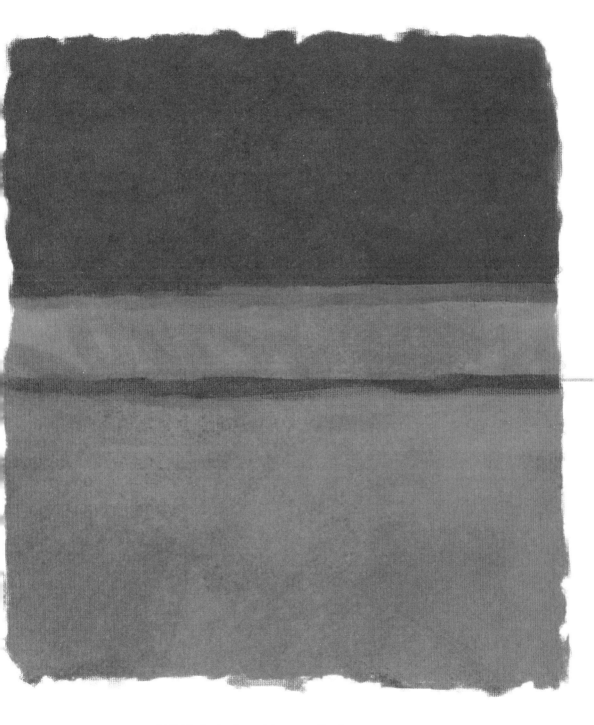

Mark Rothko, *Reds No. 5* (1961), Berlin State Museum, Berlin

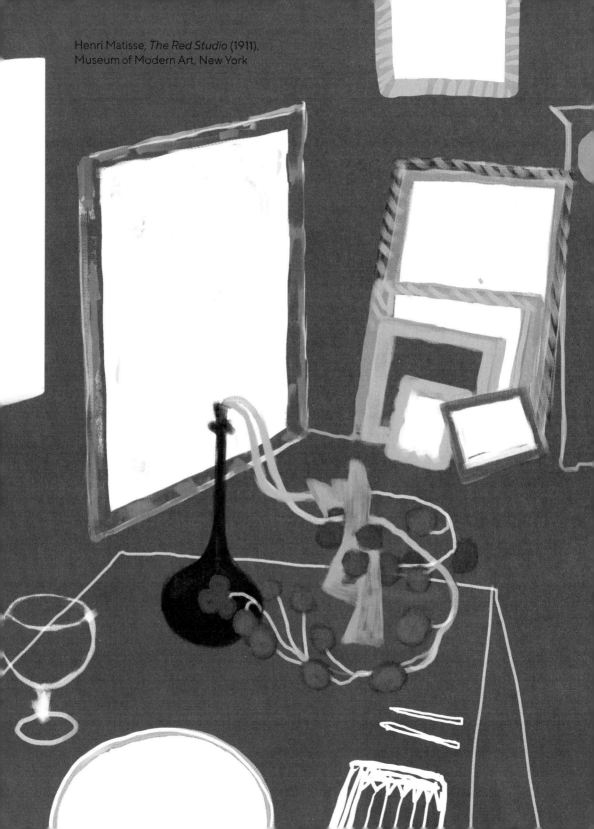

Henri Matisse, *The Red Studio* (1911),
Museum of Modern Art, New York

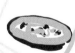
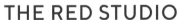

THE RED STUDIO

Rothko said that the picture that affected him most and changed the way he painted was *L'Atelier Rouge* (*The Red Studio*) by Matisse. He said that standing before this painting you could imagine becoming color. Indeed, everything in it is red: the table, the chair, the furniture, the floor, the walls, and the clock; you really feel immersed in red or even that you are that red. Matisse loved colors per se as genuine, vital expressions. For him, red was life energy.

Your Creative Space

Draw your own studio or creative space – somewhere you feel free to observe, to paint, to draw and be creative. Make sure red is a vital component that symbolizes your creative passion.

PAINTING IN RED

Now that this book is finished, try to think of how many red things you know and make a list: from Snow-White's apple to road signs, from Santa to roses, from Little Red Riding Hood to fire. You'll notice that red is everywhere and can have many different meanings. Sometimes, it means love, other times, danger, or also heat. Draw some red things below that occur in nature.

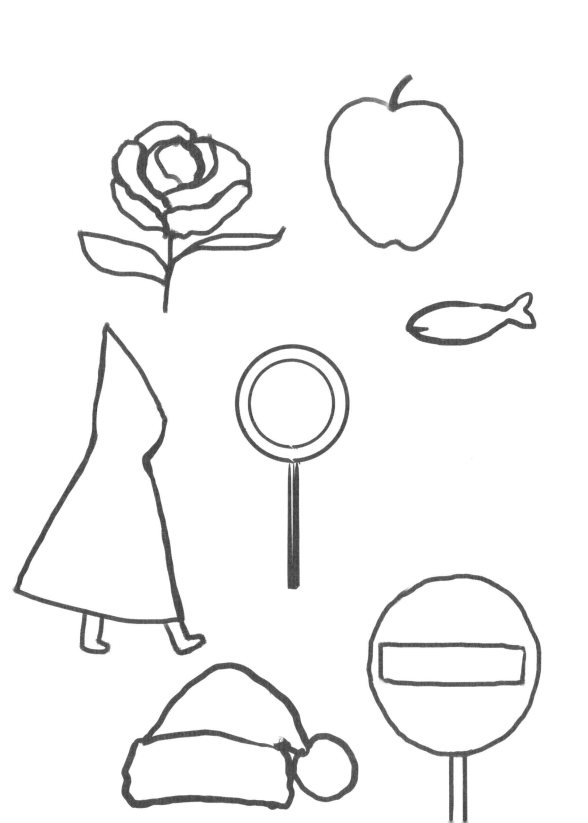

 For your last exercise, draw some red objects from around your
house.

WHERE TO FIND OUT MORE

There is a wealth of information on the internet, in museums and libraries. Use this information as a springboard for your creative exploration of the fascinating world of color.

Art Gallery of NSW, Sydney, artgallery.nsw.gov.au

Basilica of San Vitale, Ravenna, ravennamosaici.it

Cueva de Las Manos, cuevadelasmanos.org

Henri Matisse, Musee-matisse-nice-org

Leonardo da Vinci, leonardodavinci.net

Museo di Capodimonte, Naples, museocapodimonte.beniculturali.it

Museo di San Marco, Florence, polomusealetoscana.beniculturali.it/index.php?it/190/museo-di-san-marco-firenze

Museum of Modern Art, New York, moma.org

National Archaeological Museum, Florence, museoarcheologiconazionaledifirenze.wordpress.com

National Gallery, London, nationalgallery.org.uk

National Gallery of Australia, Canberra, nga.gov.au

Palazzo Vecchio, cultura.comune.fi.it/pagina/musei-civici-fiorentini

Palazzo Vecchio, Florence, musefirenze.it/musei/museo-di-palazzo-vecchio

Pompeii, Pompeiisites.org

Rosso Fiorentino, Pinacoteca, Volterra, comune.volterra.pi.it/Pinacoteca_civica

Royal Library of Turin, Turin, turismotorino.org

Sinopie Museum, Pisa, opapisa.it

Uffizi Gallery, Florence, uffizi.it

Vatican Apostolic Library, Rome, vaticanlibrary.va

Victoria and Albert Museum, London,vam.ac.uk

ACKNOWLEDGEMENTS:

The Italian publishers would like to thank MUS.E and Giotto FILA, who partnered with them to make these books possible.

This English language edition Published in 2021 by OH!,
an imprint of Welbeck Non-Fiction Limited,
part of Welbeck Publishing Group
20 Mortimer Street
London W1T 3JW
English Translation by © Welbeck Non-Fiction Limited

First published by © Topipittori Milan in 2016
Original title: *Rosso*
www.topipittori.it

Red by Valentina Zucchi and Paolo D'Altan
ISBN 978-1-80069-056-1

Text © Valentina Zucchi and Paolo D'Altan
Translator: Katherine Gregor
Editorial: Wendy Hobson
Design: Nikki Ellis
Production: Rachel Burgess

A CIP catalogue record for this book is available from the British Library

Printed and bound in China by Leo Paper Products Ltd.

10 9 8 7 6 5 4 3 2 1